MONET'S GARDEN

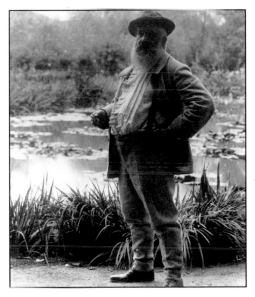

Chronicle Books • San Francisco

Monet's idea had been to create a garden like no other in its arrangement and extent. For example, he had a profusion of plants tossed into vast squares like patches of cabbages, beans or carrots. The result achieves an unbelievable intensity. Nothing is left to chance: as in his paintings, where everything appears to be spontaneous and haphazard but is not, the garden is planned with a great deal of calculation, experience, and knowledge of the laws of harmony. Few people could use the space so wisely. However, even though the method has been revealed, I would not advise anyone to try to cultivate a garden like Monet's, even if they are skilled gardeners. To begin with, the cost of such an enterprise is staggeringly expensive. For Monet, though, it was a necessary expense. First, because he is a man who appreciates splendid things – a fact clearly demonstrated by his passion for the most ostentatious of flowers. Furthermore, the garden is of admirable assistance to him in his work. It is a priceless collection of the most intense and rare harmonies: an unequalled palette.

Arsène Alexandre, 'Un Jardinier', in *Le Courrier de l'Aisne*, 1904

PLATE 1: AUTOCHROME OF MONET AT GIVERNY, *c* 1923

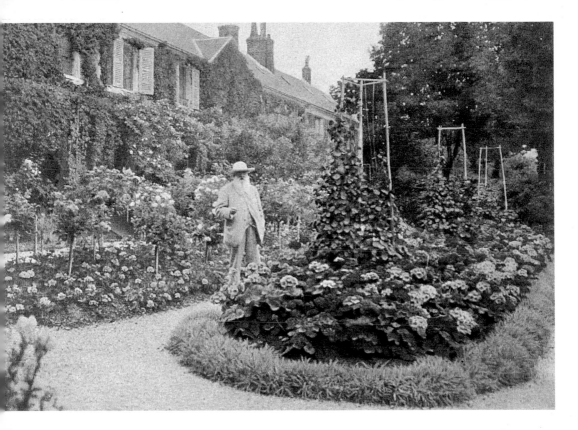

'Look there,' Monet said; 'that was once an orchard. The trees were all dead or had been felled.' The fruit trees have been replaced by groupings of the most sumptuous and varied species of flowers, irises, tulips, Japanese peonies. Blue, violet, yellow, and pink flowers are blended together in clumps of dazzling tones among the green of leaves and stems. There are no plots of grass, no baskets, no fenced flower beds – none of those arrangements that are held to be the summit of the gardener's art and that give flowers the artificial appearance of bouquets or parlour knicknacks. Here, clumped freely together on each side of the long, straight paths, the flowering plants present themselves impetuously alive.

The garden is not the luxury of some property owner, created to show off the quality of his seeds; it is the retreat of an artist, and the flowers are his companions. He wants to be able to caress them as he goes by, to feel them close to him, surrounding him, friendly and beneficent parts of his life.

Maurice Kahn, 'Le Jardin de Claude Monet', in *Le Temps,* 1904

PLATE 2: THE ARTIST'S GARDEN, 1900 (detail)

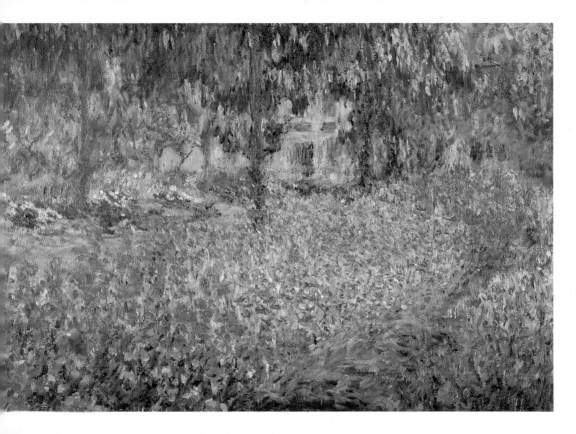

On either side of the sandy path, nasturtiums of every hue and saffron eschsholtzias collapse into dazzling heaps. The surprising fairy-tale magic of the poppies swells on the wide flower beds, covering the withered irises; it is an extraordinary mingling of colours, a riot of pale tints, a resplendent and musical profusion of white, pink, yellow and mauve, an incredible rolling of blond flesh tones, against which shades of orange explode, fanfares of blazing copper ring, reds bleed and flare, violets disport themselves, black-purples are licked with flame. And here and there, rising from this marvellous wave, from this marvellous flow of flowers, the hollyhocks dress their masts with exquisitely rumpled fabrics, as light and vaporous as gauze, their creases satin-brilliant; they bear little dancers' skirts that balloon and billow. The suns of the Texas roses reach out their long bracts heavy with buds, and the great California sunflowers leap, shoot their green eyes upward, their tousled flower heads crested with gold, like fabulous angry birds. In the air, the fresh breath of the mignonette mingles with the nasturtiums' peppery scent.

Octave Mirbeau, 'Claude Monet' in L'Art dans les deux mondes, 1891

PLATE 3: THE GARDEN, GIVERNY, 1894

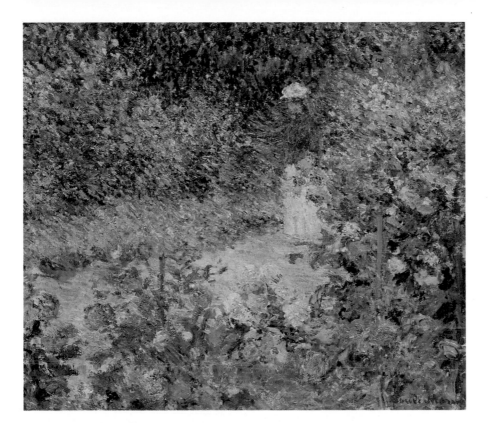

The first garden, the one next to the house, is a little like a French-type of orchard. Underneath and edging the fruit trees that have been saved, there are masses of flowers, and several gardeners are busy tending, pruning, changing them several times during the season. Along with the Japanese prints, it is one of the only luxuries indulged in at Giverny. 'More than anything, I must have flowers, always, always,' says their owner. I have been told that on the days when they are being rotated, when the ones dug up are thrown on the scrap heap, stealthy neighbours beg, 'Monsieur Monet, can I gather them?'

Entering his studio/living room is tantamount to staying out of doors; nowhere does one feel shut in . . . the walls, because they are covered with a great many luminous paintings, become insubstantial . . . fresh flowers in vases here and there form an additional transition between living quarters and nature . . . [his paintings] could well be described as an enchanted garden in which flowers of almost every season survive.

Le Duc de Trévise, 'Le Pèlerinage de Giverny' in
La Revue de l'Art Ancien et Moderne, 1927

PLATE 4: CHRYSANTHEMUMS, 1897 (detail)

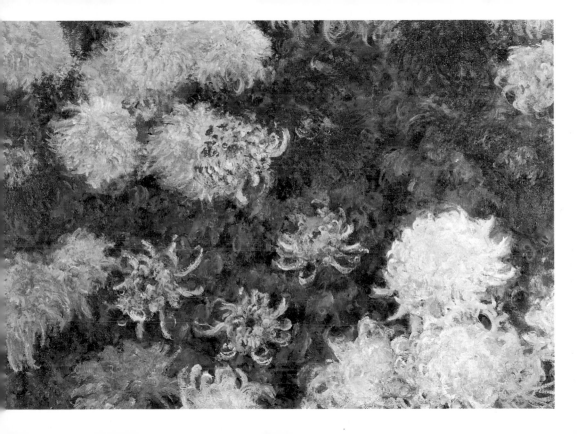

Initially the *Clos Normand* had been just a courtyard or a Norman apple orchard, which Monet once thought of planting with flowers. He did this himself, without any help and without a gardener. It was here that he conceived the polychromatic fairyland that has exerted so great an influence on his art and has brought him worldwide recognition.

In the early spring, as one enters this old-fashioned Norman courtyard ... one is dazzled by a profusion of narcissus, especially the yellow kind with large trumpets, emperor narcissus and poet's narcissus.

A week or two after this vision of early spring, the tulips come out. There are long rows of early Dutch tulips in all hues, then come the Rembrandt tulips with their striped and mottled petals that throw off brilliant spots of colour, and finally, in mid-May, the Darwin tulips on their tall stems ring out their brilliant note.

Georges Truffaut, 'Le Jardin de Claude Monet', in *Jardinage*, 1924

PLATE 5: SPRING AT GIVERNY, 1900

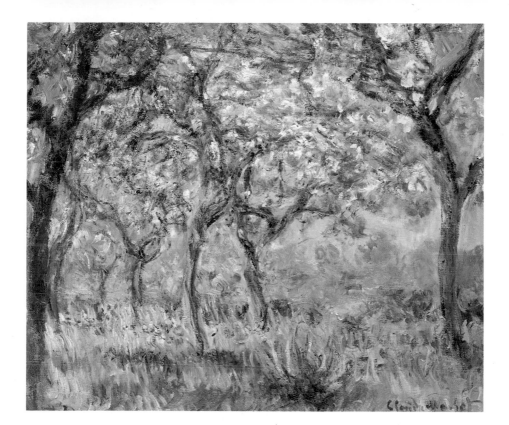

O n our left was a low wall topped by a long iron grille, perfectly simple in design; through it one saw a long, low farmhouse, having in front of it a dazzle of flowers, all common, all chosen for their brilliancy: snapdragon, African marigold, campanula, gladiolus and the like. What struck me at once was that there was no arrangement in masses. The painter has his garden before him like a canvas some fifty yards wide and rather more than half as deep; and the effect he aimed at was an effect of the whole. All was a flicker of bright colour; form was given by the use of trees, limes, conifers and one or two Japanese maples, crimson or bronze. Looking close, one could see careful planning; common willow herb had been brought in for its tall shafts of clear colour, they were ranged in clumps at intervals; nothing was let stray, yet the whole effect seemed as carelessly variegated as a wheat field where poppies and blue corn cockle have scattered themselves. All fell together like a pheasant's plumage or a peacock's.

Stephen Gwynn, *Claude Monet and his Garden*, 1934

PLATE 6: THE GARDEN, 1902

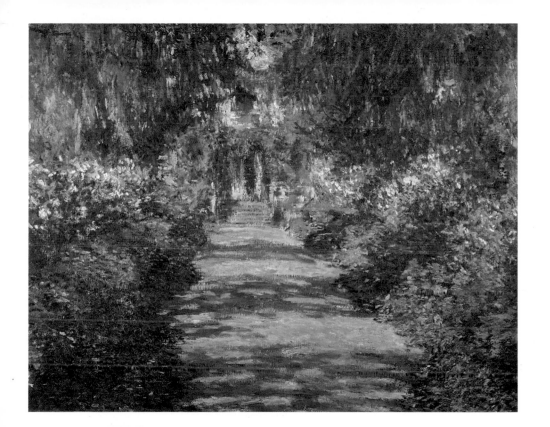

In June, roses predominate; roses in all shapes and sizes: varieties of cluster roses (even stemmed ones), bush roses, standard roses. But hardly any long-stemmed roses grafted onto eglantines are to be found in Claude Monet's garden. A few corners of the garden are planted with free-growing carnations – those pink carnations that our forefathers cultivated. Elsewhere there are hollyhocks, which are hardy even in the poor soil of Giverny, and digitalis, and finally in August there are vast numbers of flame-coloured nasturtiums, phlox planted in large beds, and the distinctive flower of Claude Monet's garden, pentstemons. Any gardener seeing the Giverny pentstemons would want to grow some.

Georges Truffaut, 'Le Jardin de Claude Monet', in *Jardinage*, 1924

PLATE 7: THE ROSES, *c* 1915-22

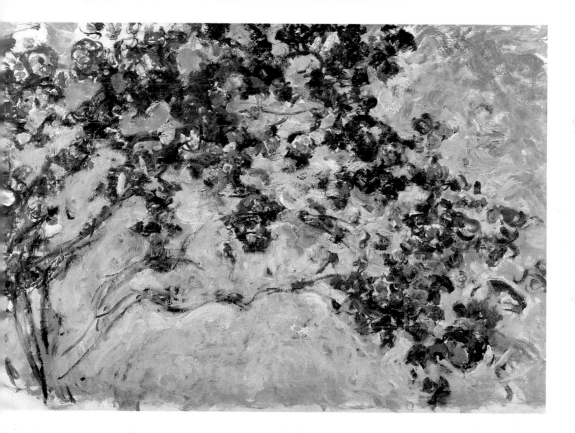

Afew simple, tall triumphal arches made of iron have just been erected above the central alley; roses will soon brightly entwine them. One truly feels the presence of a skilled organizer. Logically, the gardens of a painter should be easier to imagine than those of a writer, because the former copies and the latter describes. Nonetheless, I pictured Rostand's garden just as it was, with its arabesques and its verdure-covered latticeworks, but not Renoir's. I imagined he would like his corner of nature to be well groomed, his shrubs to have smooth, tidy leaves like the feathers of some species of birds; I certainly did not expect slovenliness, such as weeds in the gravel. And I should have thought that Claude Monet, absorbed as he often was with leafy tangles, lived in a springtime jumble; yet the most beautiful orderliness prevails. Here everything is within bounds, even exuberance; everything is artfully arranged, even the wild flowers.

Le Duc de Trévise, 'Le Pèlerinage de Giverny' in
La Revue de l'Art Ancien et Moderne, 1927

PLATE 8: THE FLOWERING ARCHES, 1913 (detail)

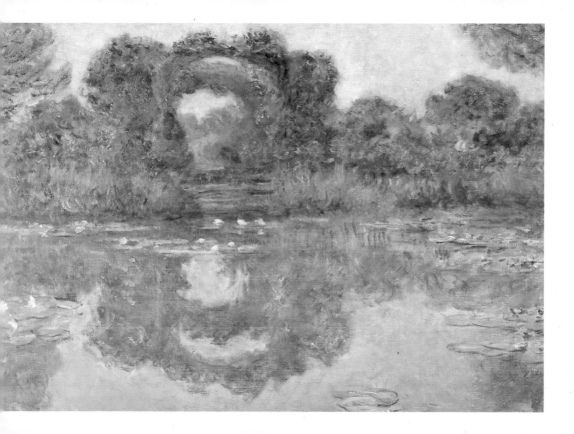

The visitor will have the illusion of being on the small island, peopled with quivering bamboo, that occupies the centre of the water-lily pond at the artist's property in Giverny. In the middle of the little lake, which feeds off the waters of the Epte river, one will see the sky and its clouds reflected in the smooth mirror of the calm water, in spots of azure and gold or of pink-tinted white; the water lilies will hold up their corollas on the wide, round leaves that carry them, sometimes yellow, sometimes white, and sometimes purple, pink or violet. On the banks, weeping willows with solid and rough trunks will rise up here and there, and their tresses will fall down in long, disconsolate threads – and one will marvel at the spectacle of this luminous fairyland, characterized by harmonies of dark blue, pink and white, green and gold.

François Thiébault-Sisson, 'Un don de M. Claude Monet à l'Etat', in *Le Temps*, 1920

PLATE 9: MORNING, WITH WEEPING WILLOWS, *c* 1916-26

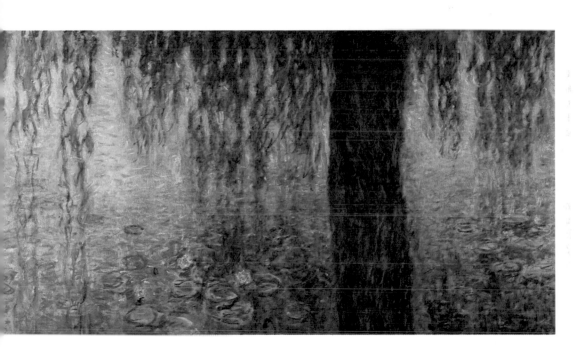

There are abundant irises of all varieties along the edges of the pond. In the spring there are *Iris siberica* and *virginica* with their long, velvety petals; later, Japanese iris (*Iris kaempferi*) abound and impart an oriental touch, which is further enhanced by such plants as Japanese tree peonies. Numerous specimens of these were sent to Claude Monet 20 years ago and have adjusted perfectly to the Normandy climate.

Toward the end of May, when the herbaceous peonies with large raggedy flowers in colours varying from yellow-spattered white to brilliant reddish purple are in bloom, surmounted by golden clumps of laburnum, one would think oneself in a Yokohama suburb. A large grove of many varieties of bamboo adds to the illusion. These bamboos have grown to tree size, 21 to 24 feet high, and form a dense wood in which the painter has provided attractive vistas.

Georges Truffaut, 'Le Jardin de Claude Monet', in *Jardinage*, 1924

PLATE 10: THE IRISES, *c* 1915-22

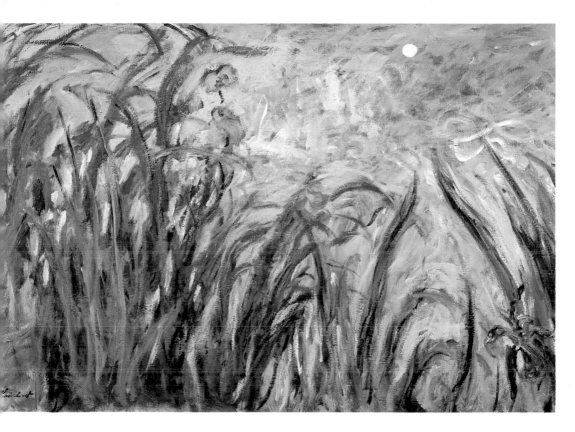

As we strolled he described how he had assembled the whole thing. From a completely empty meadow devoid of trees but watered by a twisting, babbling branch of the river Epte, he had created a veritable fairy-tale-like garden, excavating a large pond in the middle and planting on its banks exotic trees and weeping willows, the branches of which stretched their long arms at the water's edge. Around the pond he had laid out twisting and intercrossing paths arched with trellises of greenery. In the pond he had planted literally thousands of water lilies, rare and choice varieties in every colour of the prism, from violet, red and orange to pink, lilac, and mauve. And, finally, across the Epte at the point where it flows out of the pond, he had constructed a little, rustic, humpbacked bridge like the ones depicted in eighteenth-century gouaches and on *toile du Jouy*.

François Thiébault-Sisson, 'Les Nymphéas de Claude Monet', in *Revue de l'art*, 1927

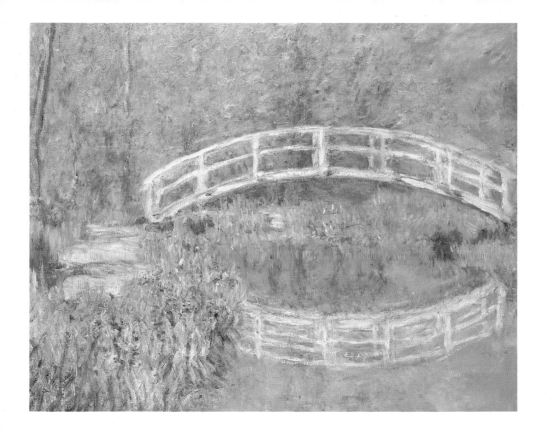

A small branch of the Epte flows through this field. It has been diverted to nourish an artificially excavated pond, upon which float the smiling water lilies I had earlier admired in the studio: spreading nenuphar lilies with huge leaves, flowers of the richest and most delicate hues; there are pink, yellow and white varieties.

A small wooden bridge painted green extends across the pond. A boat is moored to it. All around the pond are water irises, and behind them are azaleas, tamarisk trees, a weeping willow.

The overall aspect of the garden – and particularly the little green bridge – has caused it to be named the 'Japanese Garden'.

Maurice Kahn, 'Le Jardin de Claude Monet', in *Le Temps*, 1904

PLATE 12: THE WATER LILY POND, 1899

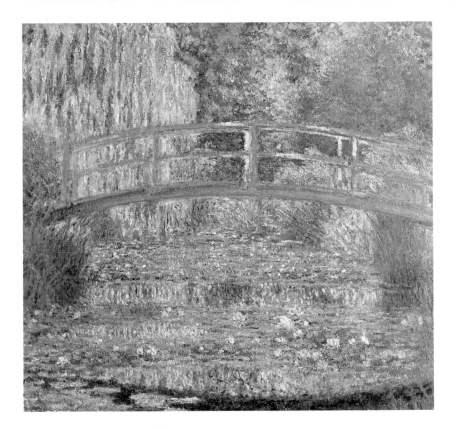

M onet told me, 'To make anything at all out of all this constant change you have to have five or six canvases on which to work at the same time, and you have to move from one to the other, turning back hastily to the first as soon as the interrupted effect reappears. It's exceedingly hard work, and yet how seductive it is! To catch the fleeting minute, or at least its feeling, is difficult enough when the play of light and colour is concentrated on one fixed point, a cityscape, a motionless landscape. With water, however, which is such a mobile, constantly changing subject, there is a real problem that is extremely appealing, one that each passing moment makes into something new and unexpected.'

François Thiébault-Sisson, 'Les Nymphéas de Claude Monet', in *Revue de l'art*, 1927

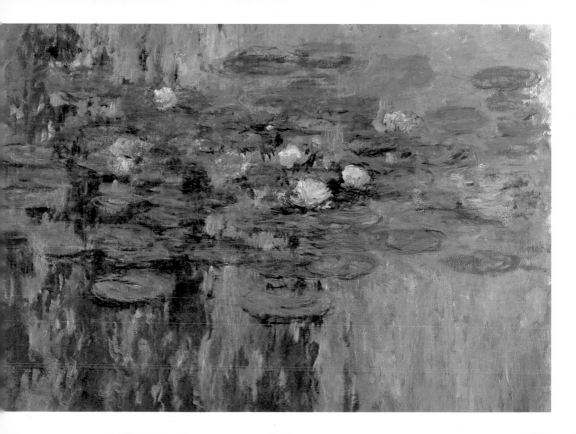

We were confronted by a strange artistic spectacle: a dozen canvases placed one after another in a circle on the ground ... a panorama of water lilies, of light and sky. In this infinity, the water and the sky had neither beginning nor end. It was as though we were present at one of the first hours of the birth of the world. It was mysterious, poetic, deliciously unreal. The effect was strange: it was at once pleasurable and disturbing to be surrounded by water on all sides and yet untouched by it. 'I work all day on these canvases', Monet told us. 'One after another, I have them brought to me. A colour will appear again which I'd seen and daubed on one of these canvases the day before. Quickly the picture is brought over to me, and I do my utmost to fix the vision definitely, but it generally disappears as fast as it arose, giving way to a different colour already tried several days before on another study, which at once is set before me – and so it goes the whole day!'

René Gimpel, *Diary*, 19 August 1918

PLATE 14: WATER LILIES, *c* 1914-17

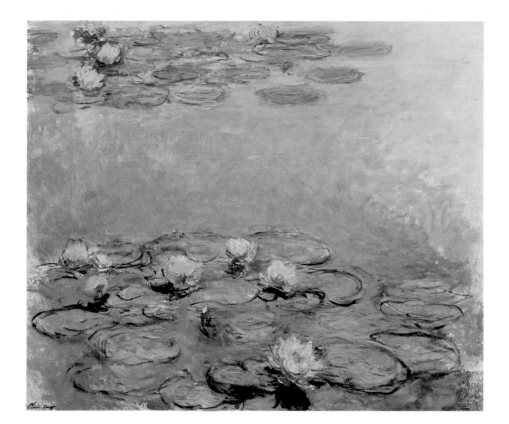

A corner seemed to be reserved for the commoner kinds of lily, of a neat pink or white like rocket-flowers, washed clean like porcelain with housewifely care while, a little farther again, others, pressed close together in a veritable floating flower-bed, suggested garden pansies that had settled here like butterflies and were fluttering their blue and burnished wings over the transparent depths of this watery garden – this celestial garden, too, for it gave the flowers a soil of a colour more precious, more moving than their own, and, whether sparkling beneath the water-lilies in the afternoon in a kaleidoscope of silent, watchful and mobile contentment, or glowing, towards evening, like some distant haven, with the roseate dreaminess of the setting sun, ceaselessly changing yet remaining always in harmony, around the less mutable colours of the flowers themselves, with all that is most profound, most evanescent, most mysterious – all that is infinite – in the passing hour, it seemed to have made them blossom in the sky itself.

Marcel Proust, *Remembrance of Things Past*, 1913

PLATE 15: WATER LILIES, *c* 1920-21

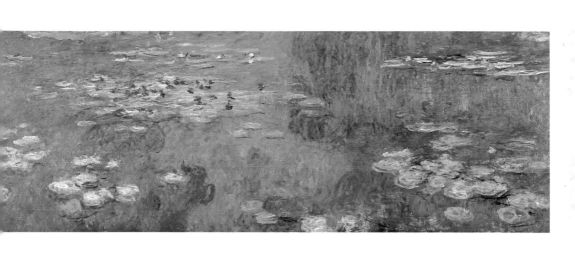

First published in the United States in 1989
by Chronicle Books

Conceived, edited and designed by
Russell Ash & Bernard Higton
Copyright © Russell Ash & Bernard Higton 1989

Printed in Hong Kong by Imago

ISBN 0-87701-647-X

Chronicle Books
275 Fifth Street
San Francisco, California 94103

5 7 9 10 8 6 4

1991 1993 1994 1992 1990